SPANISH

CENTURY

PAINTING

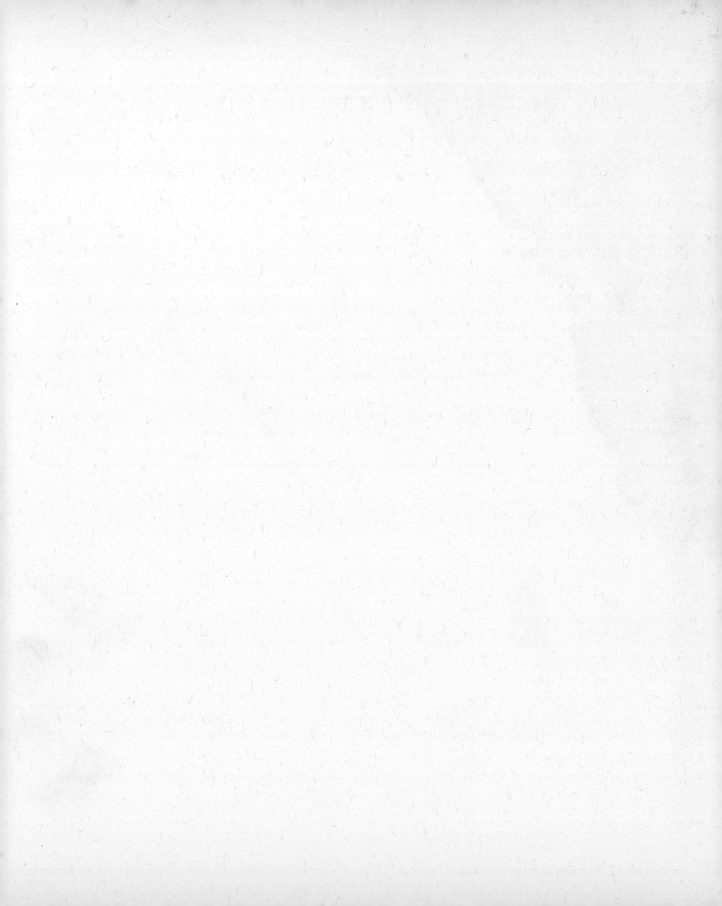

SPANISH PAINTING

THE GOLDEN CENTURY

by Carmen Gomez-Moreno

Medieval Department
The Metropolitan Museum of Art

McGRAW-HILL BOOK COMPANY
New York Toronto London Sydney

23712

SPANISH PAINTING THE GOLDEN CENTURY

Spain achieved importance as an international power at the end of the fifteenth century. By then her strength had been tempered by more than eight centuries of struggle to retrieve the territory taken by the Arabs, and a new phase of political and religious unity had been attained.

The sixteenth was the greatest century of Spanish power, but somehow the achievements of Spanish warriors and missionaries, the spirit of discovery and conquest that sent her men and ideals across oceans and through foreign lands, did not provide equal inspiration to Spain's artists. However, the rulers who created the Spanish Empire, from Ferdinand and Isabel through Charles V and Philip II, were great patrons of art and their acquisition of foreign masterpieces made the artistic treasures of the Spanish Crown perhaps the most important in Europe. Isabel the Catholic favored the Flemish school; Charles and Philip were particularly interested in the great figures of the Italian Renaissance. Both kings were portrayed by Titian whose works, together with those of Tintoretto, Veronese, and the Bassani, were acquired in great profusion. This extremely important collection later enabled some of the Spanish painters of the seventeenth century to see Italian art and take inspiration from it without leaving their own country.

The effects of the artistic fashions emanating from the court did not spread uniformly through all the regions of the Peninsula. On the East coast, particularly in Valencia, we find during the sixteenth century influences from Raphael, Leonardo, and Correggio, while in Andulusia we see the effects of the Roman Mannerists and Michelangelo. Added to these Italian influences were those from the Netherlands, then under Spanish rule. Flemish and Dutch painting, generally more realistic than that of Italy, was closer to the Spanish artistic temperament and more easily absorbed and integrated into the Spanish school.

When the vast stone structure of the Monastery of El Escorial was about finished, Philip II gave an important commission to a Spanish painter Juan Fernández de Navarrete (ca. 1526-1579), known as "el Mudo" (the Mute). Although he had studied in Venice, Navarrete had worked out a powerful style of his own, and as early as 1576 his *Burial of St. Lawrence*, painted for the church of the Monastery, shows him as a forerunner of the tenebrists (painters using a dramatic light-and-dark manner). Unfortunately, his premature death left his task unfinished and Philip, unable to find another Spanish painter of Navarrete's ability, turned to Italy where he secured a group of second-rate Mannerists, since the leading figures of the school were not available. The fresco decorations by these artists, in spite of correct design and bright colors, add no warmth to the overpowering coldness of the forbidding Monastery.

Philip II's artistic taste was very personal and unpredictable. Although deeply religious to the point of fanaticism and almost ascetic in his habits, he was passionately fond of the sensual works of the Venetian masters with their pagan goddesses reclining in all the splendour of their naked bodies. At the same time, however, he rejected the hypersensitive and mystical religious works of the most original of Spanish painters of the sixteenth century: Luis de Morales and El Greco. It is

Figure 1. El Greco: Burial of the Count of Orgaz. Santo Tomé, Toledo

El Greco, one of the great masters of all time, who marks the transition from the Renaissance and Mannerism to the Baroque without being easily enclosed in any of those styles.

Domenicos Theotocopoulos, known as El Greco, was born in Candia, Crete, in 1541, and in 1566 he was registered there as a painter. From Crete, it is believed he went to Venice for a short time and studied with Titian. In 1570 he went on to Rome. Why and when he went to Spain is not known. Most probably he was attracted, as were other artists, by the possibility of a commission to work at El Escorial. Why he went to live in Toledo is also unknown, but it may be that the exotic character of that city with its mixture of civilizations and religions appealed to his exalted and passionate artistic temperament.

By 1577 he was working in Santo Domingo el Antiguo (Color slide 1, *The Assumption*), and shortly afterward he painted *El Expolio* for the Cathedral of Toledo, a work that is very Venetian in color but not in its composition or spatial treatment. In 1579 he painted the *Martyrdom of St. Maurice and the Theban Legion* for a side altar in El Escorial. Though still using the *velatura* (transparent glazes) technique that he had learned in Venice and never abandoned, El Greco shows a complete change in color in this painting. Here the color has become much cooler, with few Venetian reds and based mostly on blues, yellows, grays, and greens of great luminosity. The picture was accepted by Philip II but placed in the sacristy, where the king had a small museum, rather than in the church proper.

In 1586 he painted his most famous work *The Burial of the Count of Orgaz* (Figure 1) for the Church of Santo Tomé in Toledo. This extraordinary picture portrays an event that took place in the fourteenth century. According to tradition, when the count died in a state of grace, St. Augustine and St. Stephen came down to bury him. The upper half of the painting represents Christ in Glory, full of light; according to Byzantine

tradition, the Virgin and St. John the Baptist are kneeling on either side of Christ to intercede for the soul of the departed, which is here represented as a naked child being carried up in the arms of a strongly foreshortened angel. While the lower half is quite realistic—the standing gentlemen are believed to be portraits—the upper half has a supernatural light in which the insubstantial figures are arbitrarily elongated, twisted in posture, and ethereal in form and color. It is the contrast between heaven and earth, the kingdom of the spiritual against the solidly constructed human world.

After 1600 El Greco painted several large compositions in which the figures present a new non-material force that propels them upward (Color slide 2). Deep spirituality is reflected in strongly asymmetrical faces; clouds seem to acquire a new importance as they become mixed with the figures; and draperies look like flames that have already consumed the body within.

Two of the best examples of El Greco as a portrait painter are the *Cardinal Niño de Guevara* in the Metropolitan Museum of Art and *Fray Hortensio Paravicino* in the Boston Museum of Fine Arts (Figure 2). Paravicino was a Trinitarian monk and an inspired poet, a friend of El Greco's to whom he dedicated at least one poem. This, one of the most disturbing portraits ever painted, is a deeply expressionistic work, painted with a freedom of brush and an arbitrary use of color that seem to belong to a period at least three centuries later. Here El Greco seems to have painted the very soul of his friend rather than his physical appearance.

During his lifetime El Greco was well understood by both the intellectuals and the simple people of Toledo. After his death he was almost forgotten, although painters like Velázquez admitted their indebtedness to him. Not until the end of the nineteenth century was this great figure again appreciated and his emotional force and powerful expressionism rightly judged.

The low ebb of the Spanish artistic tide, so far as painting is concerned, occurred at the peak of that country's international glory. This paradox apparently reflects the Spaniards' lack of understanding and enthusiasm for the ideals and order of the Renaissance. It was not until the end of the sixteenth century, when Spain had begun to lose control of its world conquests, that the strongest cultural outburst took place. Already, under Philip II, Spain had lost to England dominion over the sea, and problems in the Netherlands became more embittered with the struggle between Catholicism and the increasing power of Protestantism.

The "Golden Century of Spanish Culture" corresponds roughly to the period between Philip II's death in 1598 and the fall of the Hapsburg dynasty at the end of the seventeenth century. During that period, the pagan side of the Renaissance seldom found an echo among Spanish artists. For the most part, they remained cold to the naked beauty of the classic gods, but they were deeply interested in ordinary human nature and human values. In this late sixteenth and the seventeenth century period, the lower classes of society are depicted in Spain with a great deal more sympathy than the powerful. The same quality appears in Murillo's popular representations (Color slide 22), in Ribera's and Zurbarán's works even when they depict saints or monks, and in some of Velázquez' works.

In addition to their lack of understanding or interest in allegories and mythological subjects, the Spanish painters of the seventeenth century had no enthusiasm for the representation of heroic deeds, showing in this respect a complete detachment from the achievements of their great men. The historical paintings produced during the Golden Century in Spain are mostly commissions in which the artist did his best to present the heroic theme in the most casual way possible (Color slides 5, 19). Not until late in the seventeenth century was the king, the unattractive and weak Charles II, to be

portrayed with all the pomp and attributes of his rank. Velázquez, in his portraits of Philip IV (Figure 3) concentrated his interest on the psychological likeness, perhaps adding some spiritual qualities. Even Murillo's portraits have none of the colorful and sometimes superficial characteristics of his religious subjects, but are sober, elegant, and very good psychological studies.

Other examples of the Spanish painters' interest in reality are revealed in the great importance they gave to still-lifes which had been popular since the middle of the sixteenth century. The typical Spanish still-lifes of the seventeenth century have a sober monumentality quite different from those produced in other contemporary European schools. Simple foods and glass and crockery more suitable for the table of a peasant than of a king were favored and used sparely. The simplicity of Sánchez Cotán's and Zurbarán's still-lifes makes them look more like religious symbols than realistic copies of nature (Color slides 4, 11).

Another type, called *bodegon* (a term used in Spanish painting to describe pictures depicting foods in a tavern or kitchen setting), is very different in character from genre paintings of the Northern countries and even the works of Caravaggio (Color slide 13). No drunkards or women of easy morals are ever represented, and the characters have an unexpected dignity. These human types, seen in Velázquez' early Sevillian paintings, are closely connected with those in the picaresque novels of the same period, some of them published in Seville itself about the time Velázquez was there. Landscape as such did not interest the Spanish Baroque painters in spite of the great variety that their country offered.

Spanish painting of the seventeenth century is mainly religious. Spain had a most influential part in the Council of Trent (1545-1563) which gave to the Catholic Church a new and much needed discipline as well as new ideas for the

iconography of religious representations. Although religion had undeniably been the dominant factor in medieval art, the relationship of the ordinary man and his life to that art was limited. Religion was seen as something distant and overwhelmingly awesome. The main importance was given to the life and death of Christ, to Christ as Redeemer but also as Judge. In late Gothic art the lives and martyrdoms of saints had already become quite popular; gruesome representations of these themes were still favored in Spain at the end of the sixteenth and the beginning of the seventeenth century. But the new spirit that came with the need for a Counter Reformation, as initiated in the Council of Trent, changed the attitude toward religious teachings and, as a consequence, toward religious representations. Religion was supposed to form part of everyday life, and religious subjects had to be interpreted so they would have wider appeal. They had to be clear, easy to understand, and were intended to awake the need for meditation without fear.

The Baroque period was an active one in Spanish architecture. Madrid had become the capital in the middle of the sixteenth century, and many churches, convents, and monasteries were built when the court settled there under Philip III. Large and elaborate Baroque retables needed large paintings with religious subjects following the new iconographic requirements of the Counter Reformation. The almost complete dependence on the church and the monastic orders gives to Spanish Baroque painting a character very different from that of the contemporary Dutch school where, because of the Reformation, there was little religious art. It differed also from the Flemish, French, and Italian schools where artists were able to find a greater variety of patronage.

Spanish religious works are intimate and deeply religious. Religion does not appear as a pretext for artistic creation, but as the expression of deeply rooted feeling. As the seventeenth century progresses, religion in painting approaches more and

more toward real life; and the scenes of martyrdoms and heroic episodes in religious tradition and history are gradually replaced by more intimate and friendly scenes designed to attract rather than horrify.

This amiable interpretation of religion culminates in Andalusia with Bartolomé Esteban Murillo. But Spanish Baroque painting, like Spain herself, is full of contrasts, and besides Murillo's pictures with their religious feeling based on a divine love that is close to human tenderness and joy, we find the ascetic pictures by Zurbarán wherein mysticism is shown stripped of external disguises. Asceticism and realism appear combined in the works of Ribera, whose pictures are much more spiritual than they are often considered.

Contrasts and all, Spanish art of the seventeenth century was rather controlled until the last quarter of the century when the real explosion of the Baroque, above all in architecture, did away with what was left of classicism and was carried into Central and South America where it reached its powerful climax in combination with the local native art.

In the first third of the seventeenth century we find in Spain three main schools of painting: Castile, with Toledo as the most important center; Valencia; and Seville.

Valencia is actually the pioneer of Baroque painting in Spain with a strong naturalism in sharp contrast to the rather sugary style of its sixteenth century as represented by Juan de Juanes. The abrupt change is made by Francisco Ribalta (ca. 1564-1628). A Catalán by birth, Ribalta worked at the Escorial with Fernández Navarrete from whom he must have learned his dramatic light-and-dark manner (tenebrism), as there is no record of his ever having been in Italy. Ribalta's style is strong and masculine, using reddish tonalities and sharp contrasts of light and dark.

One of the leading Spanish painters of the Golden Century,

José de Ribera (1591-1652), was born near Valencia and was a pupil of Ribalta's. While still quite young, he went to Italy where he studied the great masters of the Renaissance and became acquainted with Caravaggio's works. For the rest of his life he remained in Naples, then under Spanish rule, and formed a school of Spaniards and Italians, some of whom went to Spain afterward and helped to strengthen Ribera's influence which was also spread by many of his own works that found their way to the Peninsula.

Ribera's style is very strongly naturalistic and masculine, and in his earlier period his realism might compare favorably with Caravaggio's. Ribera's tenebrism is very strong and his

Figure 4. Ribera:
Venus and Adonis.
Galleria Nazionale d'Arte, Rome

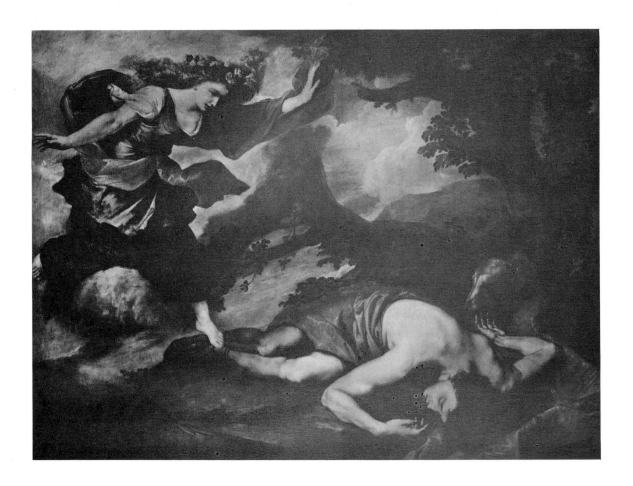

Figure 5. Ribera: Saint James the Great. Prado Museum, Madrid

figures of hermits and philosophers—who actually were and look like beggars—are true-to-life representations. His sense of color and knowledge of composition triumph over his tenebrism even in his earlier works such as the *Martyrdom of St. Bartholomew* (Color slide 6). Living in Italy, he was more concerned with mythological subjects than were his Spanish compatriots, with the possible exception of Velázquez. In *Venus and Adonis* (Figure 4), he chose to represent the death of Adonis instead of a love scene. The body of the dead shepherd has a classic beauty and gives an impression of complete repose, in strong contrast to the turbulent figure of Venus who approaches the body of her lover in a swirl of floating clothes and hair. The imaginative landscape with a large tree and heavy clouds from which the goddess emerges, help to impart drama to the scene and make even more desolate the immobility of the dead figure on the ground.

The development of Ribera's style can easily be followed by the change in light and softening of subject matter. Later his palette becomes much brighter and he uses more and more open skies; the pictures toward the end of his life appear bathed in a soft golden light. In such paintings as *The Holy Family with Saint Catherine* (Color slide 8), we cannot use the term "tenebrist" in its full meaning any more, because the figures appear fully lighted and without any sharp shadows, and the whole mood is of soft sentiment touched with a certain sadness. A greater intent and feeling for physical beauty, particularly feminine beauty, can also be perceived.

Ribera did not abandon tenebrism completely, however. The *Saint James the Great* (Figure 5) painted in 1651, one of the most monumental figures of his whole career, is strongly shadowed but without harshness. This magnificent saint shows an elegance and easiness in posture and a spirituality of expression that are quite removed from his early beggar-hermits. Ribera also had a marked influence on his contemporaries,

including Velázquez (who made a special trip to Naples to meet him), Zurbarán, and even Murillo. His drawings and etchings have been known and studied by many artists in Italy and Spain.

In spite of the great success that El Greco had in Toledo during his lifetime, he did not leave a real school. The best known of his disciples is Luis Tristán (d. 1624), a rather complex artist whose works show some of his master's elongations and light effects, but without the same sense of color.

Though not born in Toledo, Pedro de Orrente (ca. 1570-1645) lived part of his life in that city and was a friend of El Greco's son. More gifted as an artist than Tristán, Orrente is the link between the school of Toledo and that of Valencia where he went afterward and competed with Ribalta. His style shows influences from the Venetians, above all the Bassani, but he uses reddish tonalities which are closer to Ribalta's. One of his best works is the *Saint Sebastian* painted for a chapel of the cathedral of Valencia in 1616 (Figure 6). The figure of this saint is one of the most accomplished studies of the nude in the Spanish Baroque; in the middle distance Sebastian is being tended by Saint Irene after his martyrdom. The light effects and the landscape recall the Venetian school, but the angels who are flying down to crown the martyr show the influence of the works of El Greco.

Also related to the circle of El Greco is Fray Juan Bautista Mayno (1568-1649). His style of strong foreshortening and clear and cool tonalities has been compared to that of such Italian masters as the Carracci and Orazio Gentileschi, but it is not known that Mayno ever went to Italy. His subject matter is mainly religious, but there are also excellent portraits and historical subjects such as the *Reconquest of Bahía* (Color slide 5) that he painted for the Hall of Kingdoms.

Juan Sánchez Cotán (1561-1627) painted a series of pictures based on the history of the Carthusian Order and other religious works that made him quite famous in his lifetime,

Figure 6. Orrente:
Saint Sebastian.
Cathedral, Valencia

Figure 7. Herrera the Elder:
Saint Basil Dictating
His Doctrine.
Louvre, Paris

but for us he is better known as an innovator in still-life painting. Still-lifes dated 1602 already show a strong tenebrism. The *Quince, Cabbage, Melon, and Cucumber* (Color slide 4) at San Diego and even more so the famous *Still-life with a Cardoon* in the Museo de Bellas Artes, Granada, show the abstract monumentality of these works at their best.

At the beginning of the seventeenth century, Seville was the center of commercial relations between Spain and the New World and, as a consequence, became a prosperous city. This circumstance had great effect on the city's cultural and artistic activities. Its cultural life revolved around Francisco Pacheco (1564-1654) who, although a mediocre painter, was an intellectual and poet, a great admirer of everything Italian, and a man of the Renaissance by inclination. It is he, however, who con-

tributed most to formulating norms for the new iconography of Baroque painting in his famous book *Arte de la Pintura*. He was, moreover, the teacher of Velázquez and Alonso Cano.

The most important painters to mark the transition between the Renaissance and the Baroque are Juan de Roelas (ca. 1560-1625) and Francisco Herrera the Elder (ca. 1577-1656). The former shows an obvious Venetian influence with a fine sense of color and his *Martyrdom of Saint Andrew* in the Museum of Seville, reveals the turbulence of the Baroque mixed with Tintoretto-like touches.

Herrera is an interesting and controversial figure. His violent temperament is revealed in the unevenness of his pictures, which show skillful accomplishments along with clumsily executed passages. The vigor of his figures, the expressiveness of their heads, and his bold technique are seen in *Saint Basil Dictating his Doctrine* at the Louvre (Figure 7), which was severely criticized for its unorthodoxy when it was taken to France. Herrera's compositions, full of energy and movement, are entirely within the Baroque style without any Renaissance influences, Italian or otherwise.

The chief masters of the first generation of Baroque painters in Seville are Zurbarán, Velázquez, and Alonso Cano. Of the three, only the first can be considered in the Sevillian school. Velázquez went to Madrid at an early age and remained there; Alonso Cano left Seville for Madrid and later went to Granada where he started another school. Murillo, younger than the others, belongs to the second generation, as does Valdés Leal.

Zubarán was born in a town in Extremadura, and the austerity of his native region is apparent in his almost ascetic style. His deep religiosity lacks the flamboyant humanity of Murillo who has a typical Andalusian temperament. The atmosphere of artistic innovation that Zurbarán found in Seville had almost no effect on him and he remained in many ways more medieval than Baroque. He is one of the main painters of long

*Figure 8. Zurbarán:
Fray Jerónimo Pérez.
Academia de Bellas Artes
de San Fernando, Madrid*

series of scenes for the monastic orders. His compositions are not always successful, especially when they have many figures, but his color is superb even when limited to whites and grays. His famous white monks were admired in his lifetime and also in the nineteenth century by painters such as Cézanne. And his single figures of saints or monks, such as the portrait of *Fray Jerónimo Pérez* (Figure 8), reveal his gift of portraiture.

Zurbarán's success decreased in part because of the rising popularity of Murillo, whose style was much more in agreement with the new religious approach and closer to the Sevillian temperament. Although a tenebrist, Zurbarán is not Baroque by temperament. He avoids foreshortening and excessive movement. His figures are sometimes a little wooden, and his knowledge of perspective and architectural devices is limited. But in spite of these handicaps, his large paintings with monastic scenes are among the great achievements of Spanish painting of the Golden Century. His possibilities as a colorist are at their best in his representations of female saints (Color slide 12), which show a great interest in rendering the rich textures of their costumes.

Zurbarán's still-lifes prove his mystic feelings even more than do his religious paintings. Their obscure symbolism (Color slide 11) appears again in his religious subjects that show flowers or objects from everyday life treated in a symbolic way (Color slide 10). One good example of his complexity within Zurbarán's otherwise clear-cut compositions is the *Virgin as a Child* in the Metropolitan Museum of Art.

Diego de Silva Velázquez (1599-1660) is recognized as the outstanding genius of Spanish art and one of the greatest painters of all time. In the beginning he followed the new realistic approach to painting with a tenebrist technique close to that of Caravaggio and Ribera, but his own personality compelled him to realism devoid of exaggerated movement and excessive detail. Even in his early *bodegones*, we can see his

interest in human personalities, not just people. His works explore many varieties of subjects, from genre paintings and portraits to religious subjects, mythologies, historical scenes, and landscapes.

Velázquez' life at the Madrid court freed him from dependence on commissions from the Church. In Madrid he found a wonderful collection of masterpieces from several countries, a patron who admired and understood him, and liberty to follow his own artistic ideals. He was given status at the palace not only as a painter but also in other capacities, administrative as well as artistic. Twice he went to Italy where he studied the works of the great masters, painted a portrait of the Pope, and became as famous as in his own country. When he was still quite young, he met Rubens in Madrid and saw him at work. Velázquez, however, was not influenced by Rubens because Baroque exaltation did not agree with his own almost classic temperament. Velázquez also admired the works of El Greco, Titian, and Michelangelo and learned from them to elaborate his own style.

His respect and sympathetic understanding for his sitters are particularly remarkable in his portraits of beggars as philosophers, and of the jesters and dwarfs who lived in the palace. His human approach made him portray these unhappy beings with all the dignity he could impart. In the portrait of Don Diego de Acedo, called "El Primo" (Figure 9), painted in 1644, Velázquez painted his subject sitting very low to avoid showing the shortness of his legs, and focused interest on the thoughtful face with its sad expression. The big books, inkwell, and pen seem to indicate that El Primo was not just a dwarf paid to amuse the royal family, but that he had some kind of administrative function.

Velázquez' few religious paintings are not sentimental like Murillo's or mystical like Zurbarán's, but as evidenced in such early ones as *The Adoration of the Magi* (Color Slide 14) or his

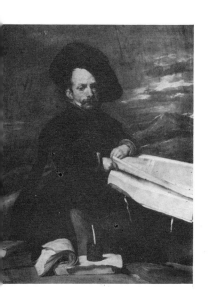

Figure 9. Velázquez: Don Diego de Acedo, "El Primo". Prado Museum, Madrid

much later *Christ of San Placido,* also at the Prado Museum, the religious theme has been handled with great serenity and deep emotion devoid of exaggerated gestures.

The same absence of superficial rhetoric is found in his mythological subjects. His pagan gods and goddesses are seen through the eyes of a seventeenth century man who was familiar with the literary texts of the stories but interpreted them according to his own point of view. He tried to see the human aspect of the myths without irony. In *The Drinkers,* painted before his first trip to Italy, Bacchus and his merry-making companions are simple, happy fellows, and the god himself is just a handsome lad. In *The Forge of Vulcan* (Color slide 15) he avoids the satirical implications of the myth and presents its human aspect without sarcasm.

For one of his greatest works, *The Toilet of Venus,* sometimes called the "Rokeby Venus" (Figure 10), painted around 1652, Velázquez chose the reclining position so much exploited by Venetian masters of the Renaissance, but reversed the familiar frontal pose so that she is seen from the back with her face reflected in a mirror held by a *putto.* The harmony of hues, from Venetian reds to dull grays and whites, emphasizes the beautiful transparency of the ivory flesh tones. The body is painted in such a smooth and subtle way that the contours in combination with the background create a feeling of volume and atmosphere. This Venus, one of the few nudes in the history of Spanish painting, is, perhaps, the most modest nude ever painted.

Towards the end of his career, Velázquez painted another picture that until recently was considered a casual view of the Royal Tapestry Factory of Madrid. *The Tapestry Weavers,* as it is called, is now considered to be the myth of Aracne (Figure 11). The real subject matter appears in the background as if on a strongly lighted stage. Minerva, in full armour, is reprimanding Aracne in front of the tapestry (representing the rape of Europa) which was woven by the latter. Three elegantly

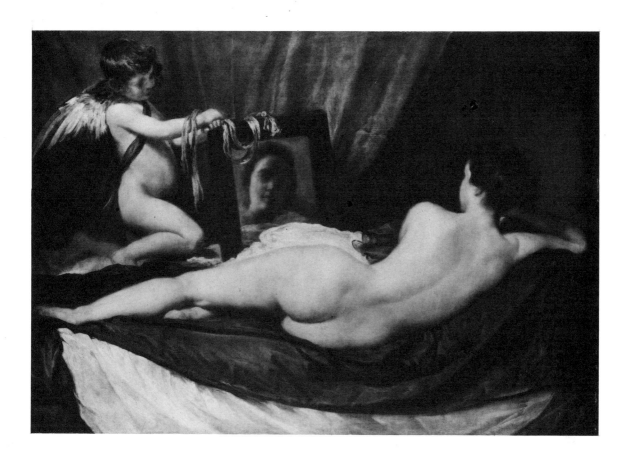

Figure 10. Velázquez:
The Toilet of Venus.
National Gallery, London

dressed ladies, one with a viola da gamba, look on. In the dimly lighted foreground, the tapestry weavers of Aracne's atelier are at work. Some of these reveal Velázquez' adaptations of the *gnudi* in Michelangelo's ceiling of the Sistine Chapel. *The Tapestry Weavers* shows the farthest development of the artist's style in retreating from plastic modelling. Here, bodies and objects are reduced to color, the atmosphere to light and flat shadows that float in space, and an overall impression of inhabited depth and of an unreal reality. It is an example of how far Velázquez' subjectivity could go and how close he comes to the artistic technique of the nineteenth century Impressionists.

While paintings like *The Tapestry Weavers, The Surrender of Breda,* or *The Maids of Honour* would be enough to explain

Figure 11. Velázquez:
The Tapestry Weavers.
Prado Museum, Madrid

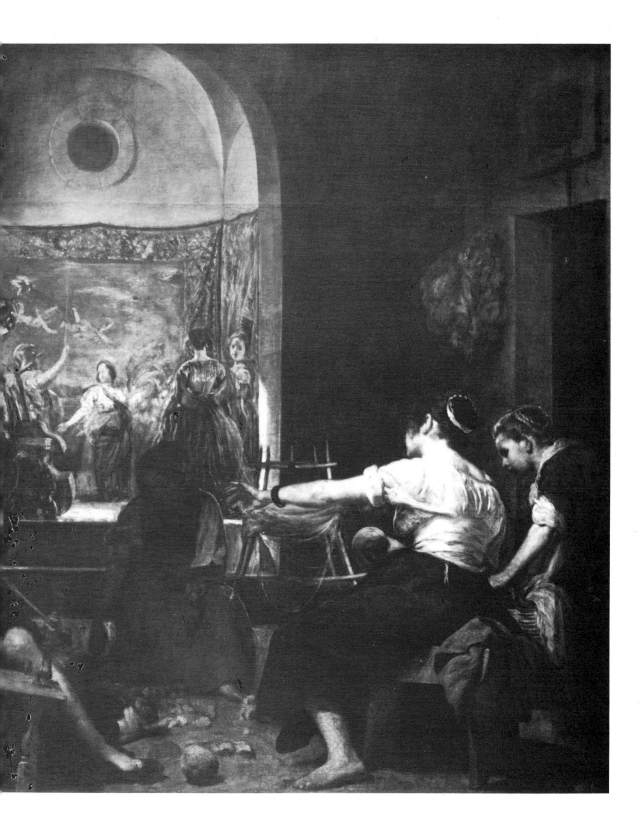

Velázquez' fame, his portraits are among his greatest achievements. He seems to depict not merely the physical appearance of his sitters but their very souls as well. His portraits of Philip IV range from the time when Velázquez met him in 1623 as a young prince with no worries to the monarch's last years when his failures and passions had made him infinitely tired, sad and prematurely old.

Velázquez also did several studies of his protector, the Count-Duke of Olivares. The equestrian portrait at the Prado endows Olivares with the same importance given to the king and the prince painted for the Hall of Kingdoms. Olivares' portrait is perhaps the only one in which Velázquez deliberately flattered his sitter, if not physically at least in presenting him as a heroic military figure.

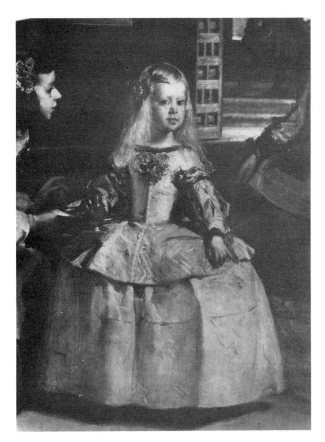

Figure 12. Velázquez: The Maids of Honour (detail). Prado Museum, Madrid

Like Goya, Velázquez always shows a deep feeling for children. We see this in the first one he painted in the *Adoration of the Magi* (Color slide 14), in several portraits of Prince Baltasar Carlos (Color slide 18) for whom he must have felt a real tenderness, and in the portraits of the Infanta Margarita, whose little figure in its tender smallness dominates the *Maids of Honour* (Color slide 20). In a detail (Figure 12) we can see the lightness of the brush work, the impressionistic handling of the jewels and the texture of the costume, and the silky weightlessness of the blonde hair. Here he has come a long way from the thick impasto and the brownish tones of his early paintings.

During his last years, Velázquez painted mostly portraits of women of the royal family: Infantas Maria Teresa and Margarita and Philip's second wife, Mariana of Austria. He used his brightest palette and most aerial touch. Whether girls or women, they look like painted and bejewelled dolls, magnificent in their rather monstrous farthingales and huge wigs.

Velázquez' influence on the French Impressionists can be measured by the enthusiasm shown by Edouard Manet when he visited Madrid in 1865. Manet wrote to Fantin Latour that Velázquez was "le peintre des peintres."

Velázquez' closest assistant was Juan Bautista del Mazo (ca. 1612-1667) who became his son-in-law and the painter of the king after Velázquez' death in 1660. Unfortunately, Mazo never fully developed his own style which therefore remained a reflection of Velázquez' art. His chief work is *The Family of the Artist* (Figure 13). In the background, working on a portrait of the Infanta Margarita, is a painter, probably Velázquez himself. In the middleground is a portrait of Philip IV, possibly by Mazo. We see in this picture much of what Mazo had learned from Velázquez and if the composition and sense of space are inferior to the *Maids of Honour*, nevertheless it shows a free brush work, sense of color, and originality.

Figure 13. Mazo:
The Family of the Artist.
Kunsthistorisches Museum,
Vienna

Alonso Cano (1601-1667) was born in Granada but went to Seville around 1614. His father was an architect and must have taught his son architecture as well as drawing. In Seville Cano studied at Pacheco's atelier when Velázquez was there, and alternated his study of painting with that of sculpture and very likely also helped his father. His disorganized, passionate, and violent temperament is not revealed in his art which is filled with a great sense of beauty, devoid of Baroque exaggerations in movement or lighting. Nor did Cano follow Velázquez' realistic representations of lower class life. In 1638 he went to Madrid, like Velázquez, under Count-Duke Olivares' protection. In spite of their difference in temperament, Velázquez and Cano were friends; as artists they were quite close in many respects, though Cano is much more an artist of the Renaissance than of the Baroque. It is obvious that Velázquez and the Venetians influenced him, as did Ribera—not the tenebrist Ribera, but the Ribera of the last period with clear skies and golden light (Color slide 24).

The years in Madrid between 1645 and 1652 were among the most important of Cano's career as a painter. His technique became much softer, less sculptural; and the shadows more transparent, the brush work very illusionistic, and the color much richer and more like the Venetians. During these years of great productivity as a painter, he almost abandoned sculpture. To this period, 1646-1648, belong *The Miracle of the Well* (Figure 14) which represents a miracle of Saint Isidro, Madrid's patron saint, a farmer, whose little son had fallen into a well; the father's prayers made the water rise, thrusting the child to the surface. This picture shows Velázquez's influence in technique, with transparent glazes and illusionistic brush work, but the original composition and the postures of the figures with strong foreshortening are completely Cano's. While the group of women indicates his ideal of feminine beauty, the poses remain natural. The figure of the saint, however, is rather

Figure 14. Cano:
Miracle of the Well.
Prado Museum, Madrid

awkward by comparison, showing the clumsiness of a man who was just a peasant even if he had miraculous powers. The color is superb with bright yellows, browns, greens, and reds.

From the same Madrid period is *Christ in Limbo* (Figure 15), an unusual subject in Baroque art. Cano displays a series of naked bodies in a way no other Spanish painter of his time would dare to do. The figure of Eve, above all, is a complete surprise. Beautifully modelled and posed, this feminine nude brings to mind Velázquez' Venus (Figure 10). Cano's painting was done no later than 1652 and the resemblance of his Eve to the Velázquez Venus is striking, with the only difference being the shape of the hip that is naturally more marked in a standing figure than in a reclining one.

Like El Greco, Velázquez did not leave a real school. Both masters were too personal and too great to be followed successfully. The Madrid school of the second half of the seventeenth century is strongly influenced by Rubens and Van Dyck, whose paintings had become very numerous in the Spanish royal collection. The usual Venetian influence all but disappeared, and no traces of tenebrism were left. The pictures of this period are filled with brilliant blue skies, bright colors, and floating clouds.

Juan Carreño de Miranda (1614-1685) is the painter of Charles II, who was not the ideal model for any painter. Carreño was at court when Velázquez was still alive and must have worked as his assistant. Velázquez' influence can be seen in Carreño's portraits of the young king and of his mother Queen Mariana, but Carreño portrayed the Queen dressed in the nunlike costume of a widow that makes her look older than she was and very different from the colorful doll that Velázquez portrayed. The portrait of Charles II at the Prado Museum (Figure 16) represents the king as an adolescent standing in the Gallery of Mirrors of the Royal Palace. The severe figure of the sickly-looking boy, dressed in black with

Figure 15. Cano:
Christ in Limbo.
County Museum of Art,
Los Angeles

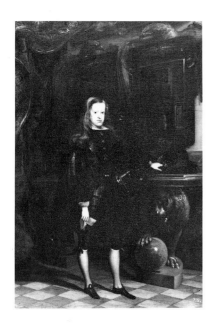

*Figure 16. Carreño:
Charles II.
Prado Museum, Madrid*

white ruffle and stockings, contrasts with the richness of the curtain, the mirrors, and the console standing on gilt bronze lions. This type of contrast together with the handling of the whole composition is much closer to Van Dyck than to Velázquez.

Carreño's palette was much brighter when he painted subjects outside the mournful walls of the palace. The flamboyant portrait of the Duke of Pastrana, also at the Prado, shows a lavish flattery of his model and a desire to impart an elegance and grandeur that perhaps the sitter did not possess—an approach often seen in Van Dyck's works. Carreño also painted religious subjects, very Baroque in concept and execution, and he did several wall decorations for churches.

There are several other painters of merit in the Madrid school, but the leading one is Claudio Coello (1642-1693) who inherited the job of court painter after Carreño's death. He studied Velázquez to more effect than did his contemporaries, above all in aerial perspective, and his works are carefully painted and designed. He is a painter of portraits and religious subjects, and his main work is the *Adoration of the Sacred Form* in the sacristy of El Escorial, painted in 1685-1686 (Figure 17). It represents the moment when a monstrance is presented for veneration to Charles II, who is kneeling and holding a lighted candle. The scene is the sacristy itself, and the picture is like a mirror wherein the whole architectural structure is reflected giving the impression that the sacristy goes on through the picture frame and beyond. The sense of aerial perspective and illusionistic depth come close to Velázquez' *Maids of Honour* (Color slide 20). None of the Madrid painters had yet attempted such an ambitious enterprise. Moreover, this extraordinary picture contains a large number of portraits of important people in Charles II's entourage.

The most important painters of the second Seville generation are Murillo and Valdés Leal. Bartolomé Esteban Murillo

(1617-1682) is known to us only through his art. He represents better than any other painter the religious approach of the Counter Reformation, with an intimacy and amiability that are far from the Baroque lushness of Rubens or the rather cold and theatrical representations of many of his Italian contemporaries. His works show a deeply felt religiosity permeated by a sweetness that sometimes seems almost too soft and feminine, especially if we compare Murillo's works with Zurbarán's or even Alonso Cano's. Murillo was never interested in scenes of martyrdom or subjects with tragic or macabre overtones. He was very interested, however, in celestial visions and miracles of the Virgin or the saints, and he represented them as believable and close to the human beings involved in them. He never appears as a mystic and least of all an ascetic. His religion is simple, pleasant, and cheerful. His representations of Mary are not idealized, but rather have the fresh beauty of the Sevillian girls—extremely feminine and innocent, but with a certain sensual appeal. His portrayals of children—Jesus, angels, little boys—all have the same characteristic of healthy vitality. He painted so many of these types and they became so exceedingly popular that a reaction set in against them in our time. He could, however, also paint in a totally different style as is revealed in his portraits, which are controlled, sober in color, and without unnecessary dramatization. A good example is the portrait of *The Canon Miranda* in the Collection of the Duke of Alba in Madrid.

Among his earlier works one of the most famous is *The Kitchen of the Angels* at the Louvre, Paris, which still shows tenebrist influence, probably from Zurbarán and Ribera. In 1665 he painted a series of pictures for the church of Santa Maria la Blanca in Seville; two of these are at the Prado Museum and represent a story connected with the foundation of S. Maria Maggiore in Rome in 352 A.D. The first is called *The Dream of the Patrician* and the second *The Revelation of the Dream*

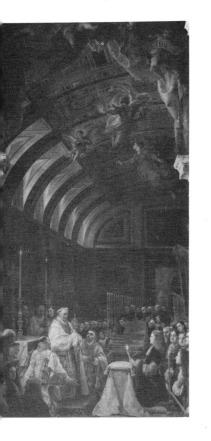

Figure 17. Claudio Coello: Adoration of the Sacred Form. Sacristy of El Escorial

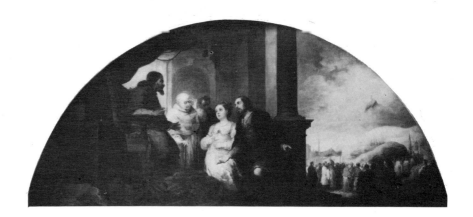

Figure 18. Murillo:
The Revelation of the Dream
to the Pope.
Prado Museum, Madrid

to the Pope (Figure 18). In the latter, Pope Liberius listens to the revelation told by the patrician who kneels with his wife. Behind the strong vertical column that divides the scene, we see a procession that arrives at the Esquiline hill and finds it miraculously snow-covered in the month of August. Above the hill in a sea of clouds the Virgin, with the Child in her arms, indicates the site where the church must be built. The technique in these pictures shows Murillo at his best, in full maturity and competently handling difficult subjects. The color, as always, is brilliant, and the light is soft and clear, giving plasticity to the forms.

It is known that Murillo went to Madrid, where in 1658 he had a chance to study the royal collection. This may explain the strong influence of such Flemish masters as Van Dyck in some of his later works such as *The Immaculate Conception of Soult* (Color slide 23).

Juan de Valdés Leal (1622-1690) is entirely different from Murillo in spite of being his contemporary and working in the same atmosphere. Valdés Leal's temperament, violent and nervous, is reflected in his work which shows a passion for excessive movement and no concern for physical beauty. He is mainly a colorist, and his technique becomes very loose and impressionistic in his last period. In works like the *Assault by the Saracens upon the Convent of San Damiano, Assisi,* in Seville,

Valdés Leal's brilliantly colored and turbulent composition recalls some of Delacroix's romantic nineteenth-century works.

His most famous pictures were painted for the Hospital de la Caridad in Seville founded by Don Miguel de Mañara, a sort of Don Juan, as atonement for his sins. Mañara's then bitter contempt for the pleasures and riches of this world found a faithful plastic interpretation in Valdés Leal's two works or "hieroglyphs of our last days," one entitled *Finis Gloriae Mundi*, the other, *In Ictu Oculi* (Figure 19). Here Leal represents Death as a skeleton, stepping on the globe of the Earth and about to extinguish the light of life around which are the words "In Ictu Oculi" (in the twinkling of an eye). Crowns, miters, scepters, staffs, armour, and books, all symbols of vanity, are piled up in a gruesome mount to show their perishability. The "vanitas" theme is typical of the Baroque period all over Europe; here at the end of Spain's Golden Age it symbolizes also the persistence of a medieval intensity of feeling and mysticism.

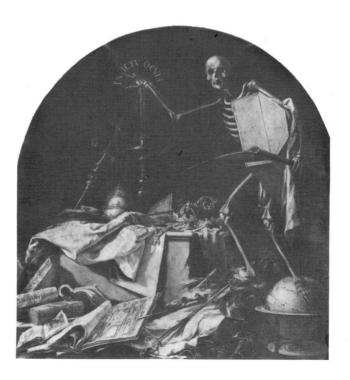

Figure 19. Valdés Leal: "In Ictu Oculi". Hospital de la Caridad, Seville

· 1 ·

EL GRECO
(ca. 1541-1614)

The Assumption of the Virgin
(1557-1579)

Oil on canvas, 158″ x 90″
Art Institute of Chicago,
Gift of Nancy Atwood Sprague

El Greco's first documented commission in Toledo was for the retable of the high altar of the church of Santo Domingo el Antiguo for which this *Assumption* was the central panel. Such paintings of El Greco's first Spanish period show his continued dependence on the Venetian masters in the brilliance of color, but in the drawing he is closer to that of the Mannerists.

This painting shows the moment when Mary is taken bodily to heaven while the apostles witness the miracle in amazement. The violent postures of these figures, their gesticulating hands and the strong diagonal marked by the tomb do not convey a feeling of depth, and the scene remains compressed and flat. This lack of concern for the illusion of a third dimension is one of the main characteristics of El Greco's work after leaving Italy. He ignores the deep Venetian perspectives of his previous pictures and recalls the flat Byzantinesque compositions of his Cretan background.

As in other paintings, such as *The Burial of the Count of Orgaz,* El Greco composed the top of the *Assumption* as an arch to give the impression of the dome of heaven against the flatness of earth. As in *The Burial,* the scene is divided into two parts: the lower represents the world inhabited by humankind and the upper the kingdom of heaven. A corner of the blue mantle that envelopes the massive figure of Mary almost touches one of the apostles like a last link with her terrestrial life.

There is no difference in the handling of the heavenly scene and the human one. The color, the lighting, and the proportions of the figures are the same in both portions and the clouds become a somewhat artificial device dividing what need not be divided.

EL GRECO
(ca. 1541-1614)

The Pentecost
(ca. 1605-1610)

Oil on canvas, 108¼″ x 50″
Prado Museum, Madrid

Painted about thirty years later than the *Assumption of the Virgin*, this work clearly shows the change in El Greco's style during those years and his complete break with the Venetian masters. The flatness of the space and the compression of the figures against the picture plane is much more exaggerated than before; the figures are very elongated and twisted in violent *contrapposto*. The heads are too small for the bodies; the expressive hands have long fingers turned upward as if to receive the light more fully; the flamelike draperies do not contain real bodies. The whole composition is compact and closed-in, making the spiritual impact even stronger.

The Pentecost was a Jewish feast day, fifty days after the Crucifixion. The Holy Spirit is said to have then descended upon the apostles and inspired them to go and preach to all nations. Though the presence of Mary is not mentioned in the *Acts of the Apostles* (2:1-11), she is usually represented in the Pentecost as sitting among the apostles, above whose heads the flame of wisdom burns. The entire scene is bathed in the divine light emanating from the Holy Spirit symbolized by a dove.

El Greco followed tradition in his interpretation of the subject and added another figure to the composition—that of Mary Magdalene whose profile appears to the right of the Virgin's head. It is not definitely known for whom El Greco painted this work, but it is thought to have been for a convent in Madrid.

· 3 ·

EL GRECO
(ca. 1541-1614)

View of Toledo
(1605-1610)

Oil on canvas, 47⅞″ x 41¾″
The Metropolitan Museum
of Art, New York,
The H. O. Havemeyer Collection

The city of Toledo was depicted by El Greco in the background of *The Laocöon* (National Gallery, Washington), in a *Crucifixion* (Cincinnati Art Museum), and in the *Assumption of the Virgin* (San Vicente, Toledo)—all of which were painted in his last period. He also painted two views of the city itself: one, in the El Greco Museum in Toledo, is an accurate topographic representation of the city as it was in El Greco's time; and this, a more imaginative interpretation that is pure landscape.

This outstanding work is the first landscape in which an artist, instead of mirroring a fragment of nature, has tried to put together all the elements that he perceived in the soul of that setting. When we look into our recollections of that city, the images of those buildings become juxtaposed in our minds in the same way that El Greco pictured them. What he painted is not a faithful recreation of actuality; it is an unearthly invention. The light seems more metaphysical than real; the city is ghostly against the dark sky under broken clouds bordered with a sharp light—giving sparkling highlights to the buildings and making the green of the wind-torn trees look like emeralds. On the banks and in the dark waters of the river Tagus, which cuts deep into the rocky foundations of the city, some tiny figures go about their business unmindful of the drama of the surroundings.

FRAY JUAN SANCHEZ COTAN

(1561-1627)

Quince, Cabbage, Melon and Cucumber

(1600-1603)

Oil on canvas, 25½″ x 32″
Fine Arts Society of
San Diego, California

Still-life subjects were favored by Spanish painters of the seventeenth century, but one of the greatest of these still-life painters, Sánchez Cotán, was not discovered as such until the twentieth century. This painting belongs to his earliest period in Toledo before he went to Granada to become a Carthusian monk.

Sánchez Cotán's still-lifes are a combination of strong crisp realism, shown in the depiction of the humble vegetables, and an almost metaphysical abstraction in the conception of the entire composition. In all of them the vegetables are placed on a window-sill against a very dark background. The arrangement is assymmetrical and, more often than not, follows a hyperbolic curve that passes through reality briefly and goes out again to infinity. Within this curve the fruit and vegetables are described in a realistic and carefully rendered simplicity, with no attempt to create easy beauty or to make the foods appetizing, as northern still-lifes do.

This still-life represents a sharp break with the ideals of the Renaissance, perhaps more than Caravaggio's fruit and flowers do, in spite of the strong light-and-dark quality that links both artists. Sánchez Cotán is much closer to the artistic taste of our time than any other still-life painter of his day. Only Zurbarán, who undoubtedly derives from Cotán, also uses real products of nature as symbols in compositions that take us far beyond the concrete frontiers of our limited world.

JUAN BAUTISTA MAYNO

(1568-1649)

The Reconquest of Bahia

(1635)

Oil on canvas, 121⅞″ x 150″
Prado Museum, Madrid

One of thirteen paintings commissioned by King Philip IV to commemorate Spanish victories, and done for the Hall of Kingdoms, this scene portrays the recapture of the Brazilian seaport from the Dutch in 1625.

Here we have an example of the fact that Spanish painters of the seventeenth century were not attracted by allegories and heroic scenes. The actual theme of the picture takes about one-third of the whole space and is overpowered by the much more realistic and appealing scene at the center and left. At the right Don Fadrique of Toledo, the victorious commander, offers to a group of citizens and soldiers a tapestry on which King Philip IV is heroically represented. This part of the picture seems artificial, as though it had been forced upon the artist.

A group of people, sheltered by rocks, is isolated from the former scene. In the center a wounded soldier is tended by a woman while a man holds his head. The light is bright on the rounded shapes without any strong contrasts of light and shade, while the colors are clear. The figure of a young woman with a child on her lap and the two small boys playfully wrestling behind her add to the impression that Mayno focused his interest on these highly human and touching scenes.

In contrast to his contemporaries, Mayno strikes a modern note in the composition and the broad, almost geometrical handling of volumes. The brightness of his atmospheric effects reminds one a great deal of some of El Greco's early paintings which Mayno had seen in Toledo.

· 6 ·

JOSE RIBERA
(1591-1652)

*The Martyrdom of
St. Bartholomew*
(1630 or 1639)

Oil on canvas, 92⅛" x 92½"
Prado Museum, Madrid

In this representation, Ribera chose to show the preparations for the martyrdom of St. Bartholomew instead of the actual flaying. Moving away from the strong influence of Caravaggio, in this particular work Ribera opened the scene to a bright sky with yellowish clouds. The figures below remain partly enveloped in deep shadows that bring out the powerful body of the saint covered only by a dark blue loin cloth. The whole composition is based on a play of strong vertical accents—the mast in the center background and the fluted columns on the right—cut by the triangle formed by the arms of Bartholomew tied to a horizontal pole and the diagonal formed by his body. Through the heavy mast, our view is led up the picture frame and beyond.

The executioners are portrayed as powerful and barbarous figures, and the saint himself is far from idealized. His strong naked body seems parched by exposure, and the long muscular arms, the narrow forehead, and high cheekbones suggest strength rather than refinement. His eyes look up brilliantly with an expression of terror mixed with hope. The passive figure of a soldier dressed in gray armour looks down at the scene, while a group of people at the left also witness the preparations with apparent unconcern. The brush strokes are bold, the paint applied freely to achieve Baroque contrasts of bright color and dark tones, and the drawing reveals the brilliance of Ribera's draftsmanship.

· 7 ·

JOSÉ RIBERA
(1591-1652)

Saint Jerome
(1640)

Oil on canvas, 49" x 38⅝"
Fogg Art Museum,
Harvard University,
Gift of Arthur Sachs

The unfolding of Ribera's career can readily be traced through the differences among the works of his early years, his middle period, and his last phase. Though he never completely abandoned a light-and-dark technique, in his last period the shadows are much subtler and the backgrounds, while less dark, are deeper. There is a considerable difference between his early naturalistic pictures of hermits and philosophers and the *St. Jerome* at the Fogg Museum, signed and dated in 1640. Apart from the lessened contrast of light and dark, this *St. Jerome* has a spirituality and dignity that are not manifest in the others, and projects an enormous inner force. The figure of the saint forms a strong pyramid against the grayish background that gives an impression of space. The uplifted head with dark hair and graying beard has been delicately modelled with transparent shadows to help convey a deeply spiritual expression. The orange-red mantle, disposed in bold and voluminous foldings about the body, brings out the pale skin of the saint, which is unlike the weather-beaten skin of *St. Bartholomew* (Color slide 6); the hand that holds the skull is subtle in modelling and elegant in design.

Ribera painted several versions of St. Jerome as a penitent. In this one the saint holds in his right hand the stone with which he will strike his chest to torture his flesh, but he seems to seek his strength and inspiration from a sphere beyond us.

· 8 ·

JOSE RIBERA
(1591-1652)

*The Holy Family with
St. Catherine*
(1648)

Oil on canvas, 82½″ x 60¾″
The Metropolitan Museum
of Art, New York,
Samuel D. Lee Fund, 1934

The last years of Ribera's life were darkened by the seduction of his daughter by Don Juan José of Austria, son of Philip IV, and the sadness of the artist permeates his work of those years from 1648—when this picture was painted—until his death in 1652. That daughter is thought to have been the model for Ribera's most successful representations of women. This *Holy Family* is an excellent example of the artist's mood and his daughter's beauty.

The Virgin is seated with the Child in her arms, and she looks out unseeingly, as if thinking sadly of what would come to pass. On her right, Catherine bends her delicate head over Jesus' hand. The richness of her garments enhances her transparent skin and soft golden tresses. The Child's reflective expression seems as though He were conscious of His real identity and what was happening around Him.

Though Baroque in style, this painting has an added monumentality and an ecstatic quality. Two strong diagonals are described by the standing figure of St. Joseph and the seated Virgin on the right, and the standing St. Ann and the kneeling Catherine on the left. Both diagonals are joined in the outstretched hand of the Child. Though the two standing figures are shadowed, the main figures in the composition are fully lighted.

· 9 ·

FRANCISCO DE
ZURBARAN
(1598-1664)

*Saint Peter Nolasco's
Vision of Jerusalem*
(1629)

Oil on canvas, 70½″ x 87¾″
Prado Museum, Madrid

Immediately after St. Peter Nolasco was canonized in 1628, the monks of his Order of Mercy asked Francisco de Zurbarán to paint a series of twenty-two pictures representing the life of their founder for their monastery in Seville. The Prado Museum now has two of them: *The Apostle Peter Appearing to St. Peter Nolasco* and *St. Peter Nolasco's Vision of Jerusalem*, both painted probably in 1629.

It is said that Peter Nolasco was bitterly attacked when preparing the regulations of his newly founded order and that these frequent attacks made him hesitate and doubt himself. In one of those despairing moments he had a vision: an angel appeared and pointed up to the Heavenly Jerusalem with its twelve doors which symbolize the many different ways to reach the Celestial Mansion.

The saint is represented as older than he would have been at that time, but Zurbarán probably used an elderly monk as a model and with characteristic honesty did not change him at all. A young peasant presumably served as model for the angel. Yet with all their realism, the figures exist each in its separate mystical envelope. The garments have sharp and well studied folds so typical of the master. The pale blue of the angel's tunic seems to glimmer and his pink mantle has a silken quality. The heavy white wool of the saint's habit falls in splendid and voluminous folds, showing Zurbarán's special gift for painting white garments with subtle shadows and harmonious shades of white. Both figures stand against a dark background that is luminous at the upper left where the vision of Jerusalem seems to float in an aura of golden light.

· 10 ·

FRANCISCO DE
ZURBARAN
(1598-1664)

The Holy House of Nazareth
(After 1630)

Oil on canvas, 65″ x 85⅞″
The Cleveland Museum of Art,
Ohio, Purchase,
Leonard C. Hanna Jr. Bequest

Though probably painted very few years after *Saint Peter Nolasco's Vision of Jerusalem*, this picture shows a further development in Zurbarán's style. Not only has his manner of placing objects and figures become clearer and more monumental, but the mystical feeling is deeper and his use of symbolism more complex. The subject matter here is very simple, but the combination of geometrical shapes, intense color, brilliant light and deep shadows is part of a complicated symbolism. The meaning of the crown of thorns and the blood is quite obvious. The sad introspective expression on Mary's face, her lack of movement to help her Son who has pricked His finger with a thorn reveal her knowledge of His destiny and the inevitability of His fate. The lilies symbolize virginal purity; red roses are sometimes used as symbols of the Passion; the dove symbolizes Divine Love; the open book is the Word of God. Also the column may mean fortitude or Solomon's temple, while the sky seen through the window may signify the storm that shook the world at the death of Christ. The light coming from the left is certainly the Divine light that falls fully on Jesus' head.

All this involved symbolism has been put down with great simplicity and the figures have been idealized without relinquishing their appearance of plain people. In the monumental simplicity of its isolated figures, the clarity of composition and the brilliant color, this is one of Zurbarán's most accomplished works.

· 11 ·

FRANCISCO DE
ZURBARAN
(1598-1664)
Still-Life
(1633)

Oil on canvas, 23½″ x 42″
Count Contini Bonacossi
Collection, Florence

Many still-lifes have been attributed to Zurbarán, but of them all the only unquestioned one is this painting, dated 1633, in the Contini-Bonacossi Collection. The objects represented here are not placed casually; they seem to have been arranged with great care, almost as if they were votive offerings placed on an altar. The complete symmetry and the stiffness of the composition are not disturbing but add to a more symbolic effect—even if that symbolism is unknown to us.

A pewter plate with four large lemons, a wicker basket with oranges that still have their leaves and blossoms, and another pewter plate with a white cup, similar in shape to those used in Spain to hold chocolate, are arranged on a table. A pink rose is reflected on the metal of the plate.

The colors are pure, the modelling subtle, just enough to give strong plasticity and tactile values to the objects which stand in glowing luminosity against the dark gray background. The whole picture is composed with honesty and artistic truth. There is no evidence that Sánchez Cotán's still-lifes were known to Zurbarán, but there is a striking relationship in the works of the two artists, perhaps because of similar temperaments and backgrounds. Cotán's and Zurbarán's still-lifes have no parallels in the art of their time either in Spain or in other countries. They were both simple and unpretentious artists, but when they took up the brush they felt themselves nearer to heaven than to earth.

FRANCISCO DE
ZURBARAN
(1598-1664)
St. Casilda
(ca. 1640)
Oil on canvas, 72½″ x 35⁷⁄₁₆″
Prado Museum, Madrid

Though he is better known as the painter of ascetic monks dressed in white, Zurbarán also painted a series of female saints between 1630 and 1650. All of them are represented in profile as if walking, and most of them have their heads turned to the spectator. Though dressed like rich ladies, their costumes seem to be of the sixteenth century rather than of Zurbarán's time. It has been speculated that they could be portraits of saintly ladies or perhaps simply of young ladies that liked to appear as saints. However, their faces are often quite doll-like which was uncharacteristic of Zurbarán. This St. Casilda is one of the most accomplished, less linear than usual and more human-looking.

St. Casilda, the daughter of a Moorish king of Toledo, carried bread to the starving Christians that her father had imprisoned. Once, when her father asked what she was carrying, she answered, "roses." When forced to open her mantle to prove it, there were the loaves of bread miraculously transformed into roses. Here Casilda appears in three-quarter view with a dignified and thoughtful pose, holding up the roses. Her dark hair and fair face are life-like without being beautiful. Quite possibly, this is really a portrait since the features project a strong personality.

In technique this is one of the most spectacular of Zurbarán's works, a *tour de force* in the rendering of the difficult textures of the complicated costume.

DIEGO VELAZQUEZ
(1599-1660)
An Old Woman Cooking Eggs
(1618)
Oil on canvas, 39″ x 46″
National Gallery of Scotland,
Edinburgh

During the years that Velázquez spent as an apprentice, he painted a series of *bodegones* (kitchen and tavern scenes with figures, utensils, and foods). Until 1957, when this picture was cleaned and the date 1618 appeared, it had been considered to be of a later date, as it was difficult to believe that an eighteen-year-old boy possessed such technical maturity.

The picture is clearly a study piece in which the young artist was trying to solve several problems of texture and reflection. The feeling of space is not yet achieved though there is an attempt to give depth to the room by hanging objects on the wall to the right and in the background. Yet, he has accomplished an impression of actuality not only in the utensils, the onion, and the frying eggs, but also in the two extremely real and human persons. There is no graduation of values here; the onion is as important as the head of the boy or the brown hands of the old woman.

The paintings of this early phase of Velázquez' career show very strong design and bold brush strokes in dominantly brown hues, rusty reds, and yellows. The contrasts of light and shade are not sharp, and the background remains dark. The face of the old woman appears in full light, while the head of the boy is softly shadowed to show the distance between them. This feeling of space and air between the figures was to become Velázquez' main interest in later works. With its smooth and thick pigment, its sharp contrasts and clearly separated forms, it suggests the early work of Caravaggio.

· 14 ·

DIEGO VELAZQUEZ
(1599-1660)

The Adoration of the Magi
(1619)

Oil on canvas, 80¼″ x 49¼″
Prado Museum, Madrid

Though Velázquez painted this *Adoration of the Magi* just one year after the *Old Woman Cooking Eggs*, his style has noticeably developed. He has now added a wider range of colors, the figures have a new volume and freedom in their postures, and the composition is more ambitious.

In 1618 Velázquez had married Juana Pacheco, daughter of his teacher, and it is possible that she was the model for the Virgin. The masculine figures, with the exception of the Moorish King, are the same ones that appear in some of his early *bodegones*. The scene has been interpreted almost like an episode of everyday life, but the holy figures, if not idealized, are impressive because of their noble bearing and serious expressions. Mary's pose is natural and full of maternal feelings while the Christ Child is charmingly portrayed with happy expression and intelligent eyes. The heaviness of the draperies, the fully lighted figures against the dark background, and the emphasis on a strong diagonal going from the head of the Virgin down through the kneeling king recall some of Ribera's works.

Another new feature of Velázquez' *Adoration* is the landscape that can be seen through the arch in the background. Though the reddish light of the rising sun is still artificially rendered, the tree on the left is a predecessor of the tree he was more than twenty years later to place on the front plane of his outdoor portraits with their landscape backgrounds.

· 15 ·

DIEGO VELAZQUEZ
(1599-1660)

The Forge of Vulcan
(1630)

Oil on canvas, 87¾″ x 114″
Prado Museum, Madrid

Velázquez matured as a painter in the Italian atmosphere of Francisco Pacheco's atelier where there was great regard for the humanistic ideas of the Renaissance. Moreover, when Velázquez went to Madrid and became painter to the king, he was able to study pagan mythology in the marvelous royal collection of works by Titian and other Italian masters. During a trip to Italy in 1630 he painted *The Forge of Vulcan* and brought it back to Madrid as a present for Philip IV. It is a vigorous Baroque study of the human body, expression, well-balanced composition, and masterly unification of space, light, and atomsphere. Velázquez interprets the moment in which the god Apollo enters Vulcan's forge and tells the ugly malformed husband of Venus about her affair with Mars. The reaction of Vulcan and his assistants has been strongly expressed by the surprise and concern depicted on their faces.

This picture shows a complete change in Velázquez's technique. What was left of his earlier Caravaggesque light-and-dark technique has disappeared. The brush work is much freer, the paint more fluid, and there is a new interest in light and in the problem of aerial perspective. The figures move with ease and elegance revealing his study of antique as well as Renaissance models, and there is great skill in rendering of the nude.

41

DIEGO VELAZQUEZ
(1599-1660)
View from the Villa Medici
(1630 or 1650)
Oil on canvas, 17⅜″ x 15″
Prado Museum, Madrid

This view of the gardens of the Villa Medici in Rome has been called *Midday* because of its light, in comparison with its companion piece at the Prado that has been called *Evening*. Both seem to have been painted on the spot and probably in a very short time, though Velázquez may have added some touches later. Here the whole picture is a harmony of browns, blues, and greens in a somewhat impressionistic technique. The brush strokes are light and bold and the paint very fluid leaving many areas of the canvas uncovered. There is considerable difference between Velázquez' approach to landscape here and in others of his open-air pictures. In this version the figures are part of the landscape, integrated with it, and the landscape itself is solidly constructed and not simply a suggested setting for the figures. The views of the Villa Medici are objective studies of definite spots with the light of a particular moment. It is this solid construction, the advanced technique of these landscapes, that has caused some question about whether they were painted during his first Italian trip in 1629/30 or during his second in 1649/50. We may note, however, that there is not much difference between the technique used to depict the background itself and the one used for the foreground, which makes an earlier date more likely. If Velázquez had painted this view in 1650, when he was deeply involved in rendering the air and the changes made by the air between the objects close to us and those placed far away, we might expect him to have marked that distance in another fashion.

These views of the Villa Medici are considered to be the beginning of modern landscape painting and an ancestor of Impressionism. There is, however, a strong distinction between Velázquez' impression and that of the nineteenth century artists. While in the latter the impression seems to be so quick, so immediate, that it is liable to disintegrate before our eyes, in Velázquez' impressionism under the light touch, the reflections, and the changing light, there is a firm structure that always remains.

DIEGO VELAZQUEZ
(1599-1660)

Philip IV as a Hunter
(1632-1633)

Oil on canvas, 74¼″ x 49½″
Prado Museum, Madrid

Among Philip IV's many artistic projects was the decoration of a hunting lodge on the outskirts of Madrid. Aside from works by Paul de Vos and Frans Snyders, the main decoration was given to Rubens and Velázquez in 1636. The pictures by Rubens represented mythological subjects and though he made the sketches, the final paintings were mainly studio works. Velázquez' participation was extensive, including the portraits of dwarfs, jesters, philosophers, and the *Mars*, but the chief works were the three royal portraits of the king himself, his brother the Infante Don Fernando, and his son Prince Baltasar Carlos who was six years old. The king's portrait may have been done as early as 1632, but it was repainted and changed afterwards.

As in the two other hunting portraits, the king is represented standing with a dog at his feet and against a landscape background. The face has been modelled smoothly with a few transparent shadows and shows the heavy jaw of the Hapsburgs under the long upturned moustache that did not appear in Velázquez' earlier portraits of him. The relatively flat and quickly perceived figure is depicted with regal nobility and elegance. The slopes of the countryside with trees and bushes in the distance, the blue sky with passing clouds, and the golden light that bathes the whole composition are typical of that beautifully strong landscape near Madrid. The dog is as realistic as all Velázquez' dogs, and in this particular case is very dignified and meditative. The tree against which the man and the animal are outlined might look a little too stage-like, but it fulfills its function of bringing out the dark gold hair and the figure of Philip.

Essentially pictures of this kind mark Velázquez' emergence into the field of *plein-air* painting and these pictures although done in the studio render the same sensation of out-of-doors and of visual immediacy as those of Manet in the nineteenth century, which they anticipate.

· 18 ·

DIEGO VELAZQUEZ
(1599-1660)

*Prince Baltasar Carlos
on Horseback*
(1634-1635)

Oil on canvas, 82″ x 68″
Prado Museum, Madrid

In the Hall of Kingdoms, besides the large paintings celebrating Spanish victories, there was also a series of royal equestrian portraits, mostly by Velázquez. The best of the series are the portrait of Philip IV mounting a beautiful charger and this charming picture of Baltasar Carlos at age five or six. The latter work was supposed to hang above a door, which explains the strange perspective and the exaggerated thickness of the pony's body.

This portrait is one of the greatest masterpieces to come from Velázquez' brush. The technique is so subtle, the brush work so airy, the coat of paint so thin that the whole seems to be felt rather than painted. As in the *Adoration of the Magi*, the artist's tenderness for children is revealed here, but now he is also in complete possession of his extraordinary technique. The blond head of the little prince under the heavy hat seems almost untouched; the shadows are transparent, the impasto thin, and the features barely insinuated, yet all the charm and innocence of the child are magically created. There is nothing sentimental or oversweet, and the little prince is full of dignity.

The landscape, as in the equestrian portrait of Philip IV, is a very personal interpretation of the Sierra del Guarrama, the mountains north of Madrid. The sky and the mountains are blue, and the distance between the mountains and the middle ground has the bluishness that colors take on when they are diffused by distance.

· 19 ·

DIEGO VELAZQUEZ
(1599-1660)

*The Surrender of Breda
("Las Lanzas")*
(1634-1635)

Oil on canvas, 121″ x 144½″
Prado Museum, Madrid

Among the battle scenes in the Hall of Kingdoms was *The Surrender of Breda* or as it is often known "Las Lanzas" because of the lances or spears on the right. Velázquez must have finished it just in time for the inauguration of the hall in April 1635.

The Dutch stronghold of Breda after a long siege surrendered to the Spaniards in June 1625, Velázquez chose to portray the moment when the vanquished Justin of Nassau, about to kneel to present the keys of the town to General Spinola, is spared the humiliation by the friendly and sympathetic gesture of the victor. There is an interesting contrast between the pale face and slender figure of Spinola and the high complexion and heavy costume of Nassau. Some of the heads of the Spaniards behind Spinola seem to be portraits.

Velázquez' open-air technique reaches a height here, and the color attains a new brilliance not equalled until modern Impressionism. The landscape creates a sense of depth that is enhanced by alternating zones of light and transparent shadow.

Although Velázquez' precision with the brush was immense, he sometimes went back to a leg, an arm, or a head in a canvas long finished and changed it, painting another on top. These so-called *pentimenti* are one of his characteristic features. *The Surrender of Breda*, under x-ray, shows a great deal of alteration, even whole groups of figures taken away and replaced by others to strengthen the balance of the composition.

· 20 ·

DIEGO VELAZQUEZ
(1599-1660)

*The Maids of Honour
("Las Meninas")*
(1656)

Oil on canvas, 125″ x 118½″
Prado Museum, Madrid

This painting, generally considered Velázquez' greatest masterpiece, is called in Spanish *Las Meninas*. "Meninas" were very young unmarried ladies-in-waiting from noble families. The center of the group in the foreground is the little Infanta Margarita (then five years old) with her retinue. King Philip and his second wife Mariana of Austria are reflected from the front of the space in a large mirror hanging in the center background. We can see only half of their figures under a red curtain. Velázquez himself appears at the left, presumably painting the parents.

The impression of reality is so strong that we feel ourselves invited to enter the composition, yet it gives us a disturbing feeling of intruding.

The light that illuminates the main group comes from a window on the right. In the opened door, outlined against the light coming from outside, stands a marshall of the palace who seems about to go out but turns his head towards us. Most of the characters in this scene, in fact, are looking in our direction. The multiple invisible diagonals traced from their eyes are like threads that pull at us, exercising a magnetic attraction to make us enter the room and take part in the scene. A sense of depth is given by the vertical accents of the pictures and the window openings on the right and also by the presence of a ceiling.

This is perhaps the loosest and most impressionistic of all Velázquez' works. It has no contours, only subtle brush strokes and modelling done with light. The face of the Infanta, the details of her dress and those of her "meninas", if we look at them closely, are just clusters of brush strokes, the pigments completely separated, but at a distance they blend into a solid appearance. Velázquez has captured here a fugitive instant that could perhaps never be repeated.

· 21 ·

BARTOLOME ESTEBAN
MURILLO
(1618-1682)

Rebecca and Eliezer at the Well
(1655-1670?)

Oil on canvas, 42⅛″ x 59½″
Prado Museum, Madrid

Murillo's uncomplicated and rather sweet pictures must be viewed with completely different eyes than Velázquez' paintings, taking into account the different temperaments and backgrounds of the two artists. Murillo lived his life in Seville. However, he did make a trip to the capital where he was able to study the works of Italian and Flemish masters, and their influence is often shown in his own works.

The subject matter of this picture is taken from the Book of Genesis (24-28) and describes how Eliezer, seeking a wife for his master Abraham, finds Rebecca at a well. In Murillo's interpretation, Rebecca is giving water to the thirsty traveller while three peasant women look on curiously. The subject is treated simply as a genre theme. The four young women, are Sevillian peasant girls wearing the costumes of Murillo's time. They all look alike, with their dark hair and eyes and pleasant features, and they assume perfectly natural and easy postures. The landscape is without the sense of depth that we saw in Velázquez. What is beautiful here is the light and the sense of color, both of which are very characteristic of his art. In earlier works his outlines had been harsher and the contrasts of dark and light stronger. Here, however, the color has been applied softly, in the Van Dyck manner, and the contours have a "sfumato" or smoky quality, not unlike Correggio's, that gives a unified atmosphere to the whole picture.

· 22 ·

BARTOLOME ESTEBAN
MURILLO
(1618-1682)

The Melon and Grape Eaters
(1650-1660)

Oil on canvas, 57″ x 41¼″
Alte Pinakothek, Munich

Murillo's personal goodness and kind disposition are clearly revealed in his approach to subjects such as this one: two dirty urchins eating, with real pleasure, a melon and some grapes from a large wicker basket. It is a genuinely picaresque piece. The boys are neither unhappy nor concerned with their poverty, but at that moment are enjoying their luck while it lasts. Murillo is not trying to give us a lesson on the injustices of society, but he is full of sympathy and understanding for these children. When Velázquez, in his early Sevillian *bodegones* such as the *Old Woman Cooking Eggs,* painted lower class scenes, he lent them his own dignity; although he sympathized, he saw them at a distance. Murillo, on the other hand, is close to his subjects, seeming to live with them and to understand them without any philosophizing. His approach emphasizes the simple joys of life that exist even in misery and poverty.

He painted several subjects of this kind, which were taken out of Spain in the nineteenth century. Their technique is very free and effective, and they do not seem to belong to any specific period. Even after Murillo's reputation as a master declined, these essentially picturesque scenes survived and continued to be considered as good paintings.

· 23 ·

BARTOLOME ESTEBAN
MURILLO
(1618-1682)

Immaculate Conception
(ca. 1678)

Oil on canvas, 107¾″ x 74⅞″

Murillo's greatest popularity was reached through his many sentimental paintings of the Virgin and Child and the Immaculate Conception. Some of these were copied and reproduced in great numbers, but eventually their popularity declined.

Though the representation of the Immaculate Conception of Mary goes back to Byzantine times, an actual cult grew up around it early in the seventeenth century as part of the Counter Reformation. This cult acquired more popularity in Spain than in any other country, and Francisco Pacheco in his *Arte de la Pintura* gives precise instructions about the manner of representing it. Mary had to appear as a very young woman dressed in a white tunic and blue mantle, surrounded by light and angels and standing on the crescent moon and the globe of the earth. Murillo painted no less than sixteen Immaculate Conceptions following the established pattern, but he superimposed his own ideas of grace and femininity. The earlier ones were like young Sevillian girls, very natural in appearance and with an innocent sensuality.

This *Immaculate Conception,* painted about 1678, is known as "de Soult" after the Napoleonic marshal who took it from Seville in 1813. The influence of the Flemish masters, particularly Van Dyck, is quite clear in this picture. The composition is more ambitious than the earlier ones, and the modelling of Mary's face and hands are very Van Dyckian. This Virgin is more majestic and sophisticated than her Sevillian predecessors, and while the group of angels around her still show some Andalusian features, they are also softer and treated in a less individualistic way than the earlier ones.

Though more theatrical and less appealing than the earlier Immaculate Conceptions, in this painting Murillo's technique shows a maturity and an assimilation of the great Flemish masters blended with his own personal style.

· 24 ·

ALONSO CANO
(1601-1667)

Virgin and Child in a Landscape
(ca. 1646-1656)

Oil on canvas, 64″ x 42″
Prado Museum, Madrid

Alonso Cano is one of the most interesting masters of Spanish art of the seventeenth century because of his activity as architect, sculptor, and painter. He has the humanistic outlook that was fostered by the Italian Renaissance, and his style is more classic and less baroque than that of any of the painters we have discussed so far.

Though a contemporary of Velázquez and Zurbarán and an influential force on Murillo's art, Alonso Cano stands somewhat apart from them. His representations of the Virgin and of female saints show an idealized feminine beauty permeated with a certain sadness, as we see in this *Virgin and Child in a Landscape*. The painting is also known as *The Virgin of the Stars* because of the crown of stars that encircle her head like luminous points. As we noted in Ribera's *Holy Family with St. Catherine*, the sad expression on the Virgin's face is a premonition of the death of Christ, as is the Child's sleep. Mary's purplish-red tunic and dark mantle are in the symbolic colors used by the Venetians of the Renaissance; and the landscape with a soft light behind the slopes is also reminiscent of the Venetian masters. The composition is deep in feeling but without any baroque exaggerations.

This concept of the Virgin may bear a certain relationship to Raphael's Madonnas, but Cano displays a sense of volume and a broad handling of the draperies that derived from his own sculptural works on similar subjects. The color and atmosphere have been interpreted pictorially so as to soften and diffuse the contours, but the monumentality of the figures reminds us of Cano the sculptor.